Pieter Hugo

1994

PRESTEL

Munich / London / New York

1994 was a significant year for me. I finished school and left home. Nelson Mandela was elected president in South Africa's first democratic election, after decades of apartheid.

It was also the year of the Rwandan genocide, an event which shook me. Ten years later I was to photograph its aftermath extensively, and puzzle over its legacy.

When I returned to Rwanda on assignment in 2014, my own children were one and four years old. They had changed my way of looking at things. Whereas on previous visits to Rwanda I'd barely seen any children, this time I noticed them everywhere.

The Rwandan children raised the same questions in me as my own children. Do they carry the same baggage as their parents? Will they be as burdened by history? I find their engagement with the world to be refreshing as it seems free of the past. At the same time I'm aware of the impressionable nature of their minds.

Pieter Hugo

Plates

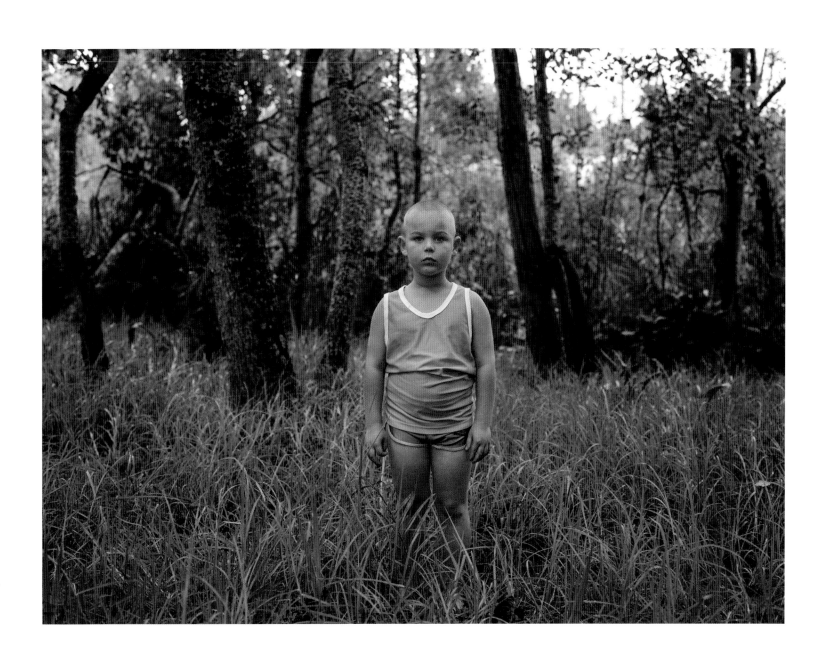

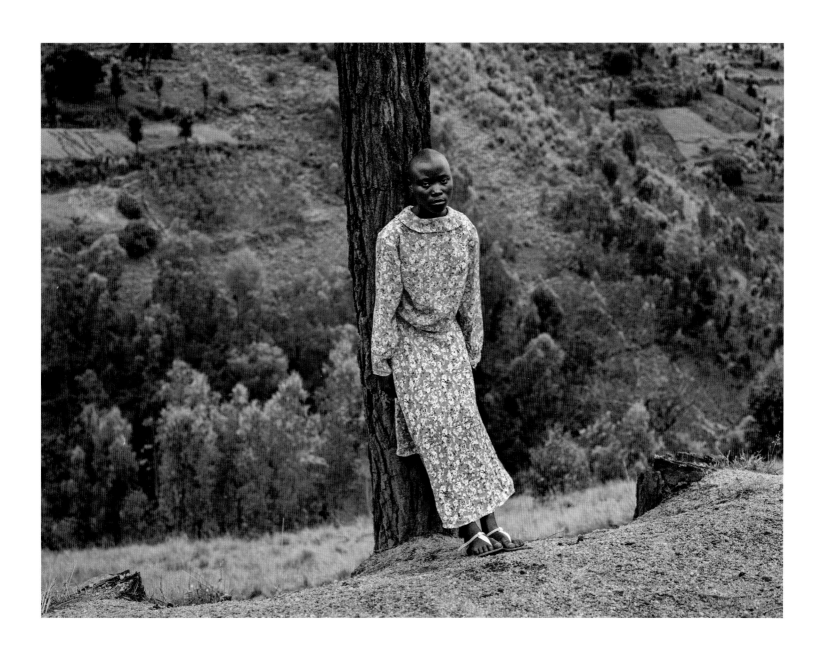

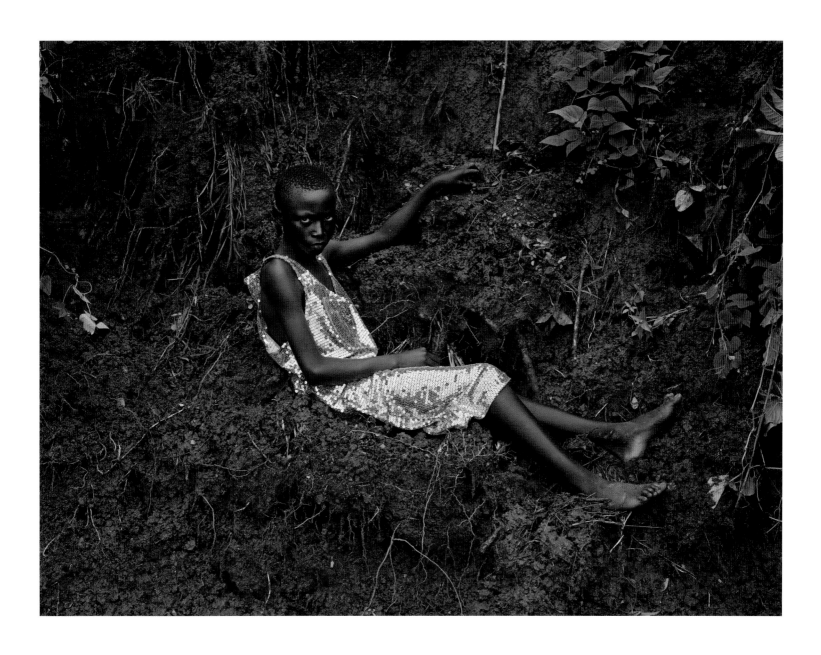

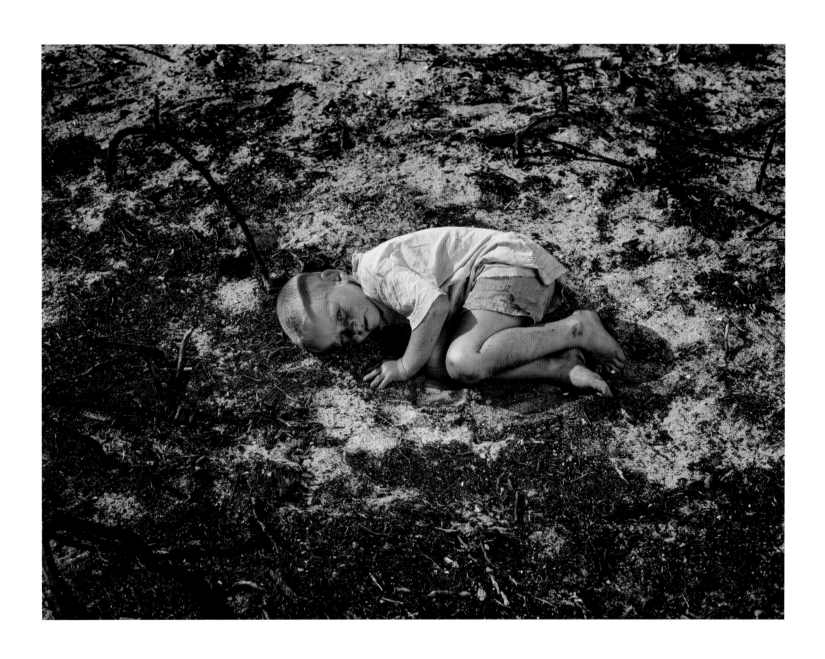

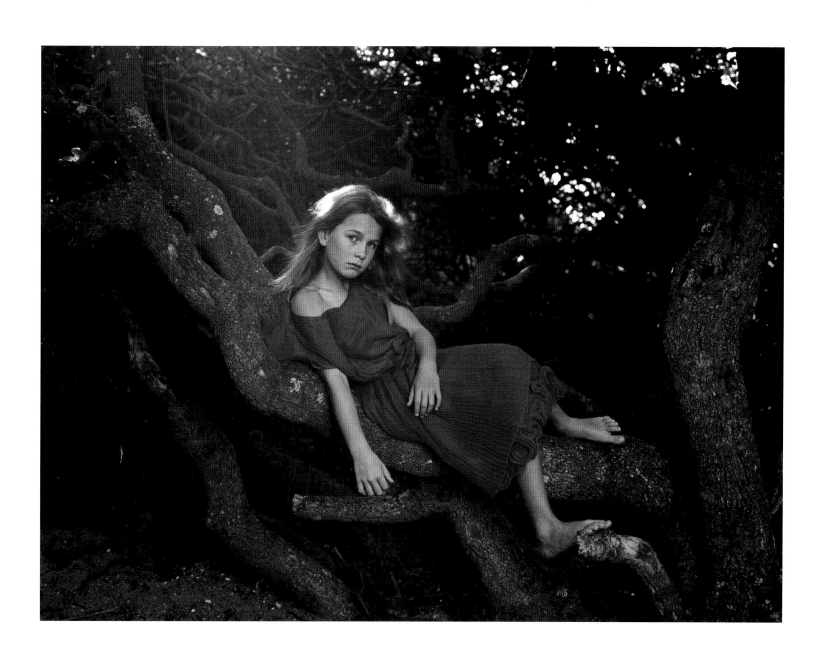

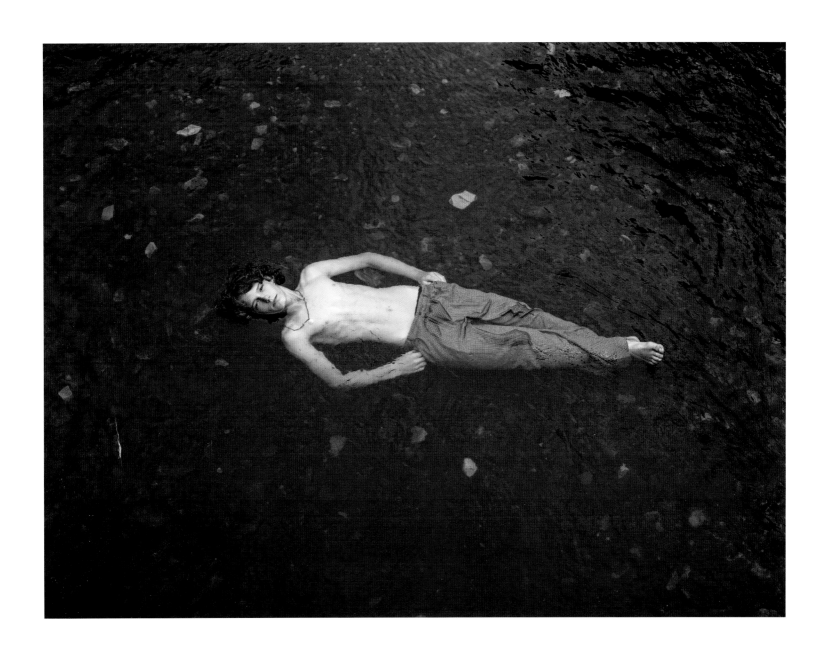

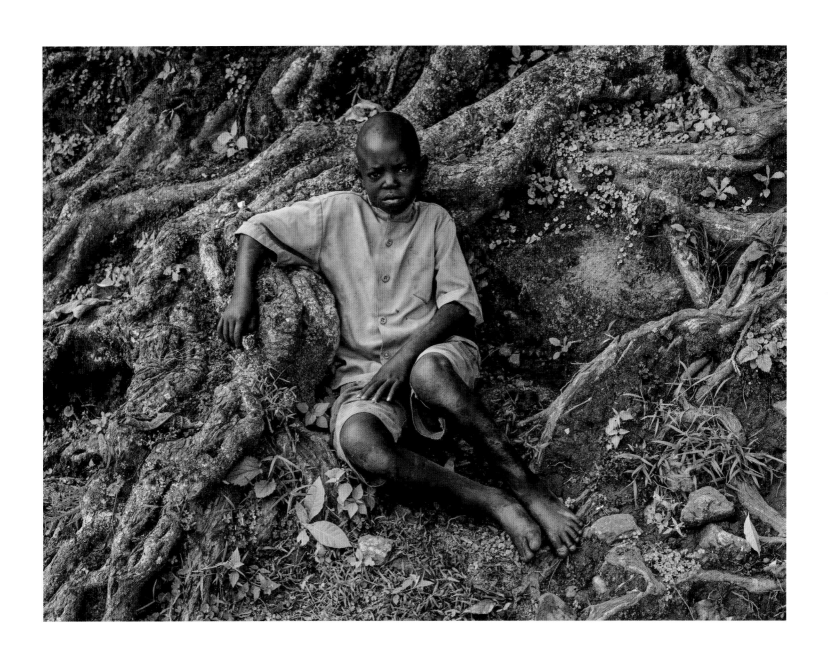

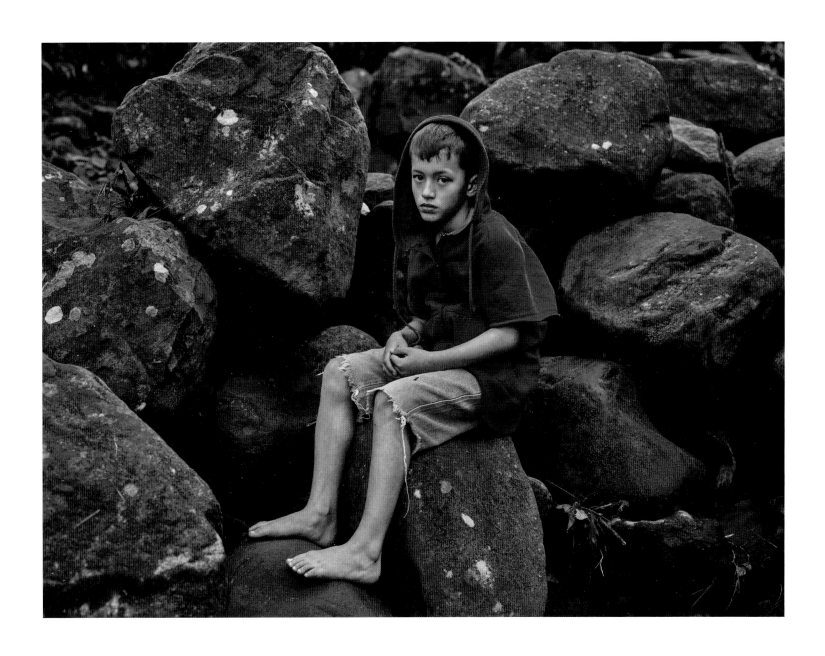

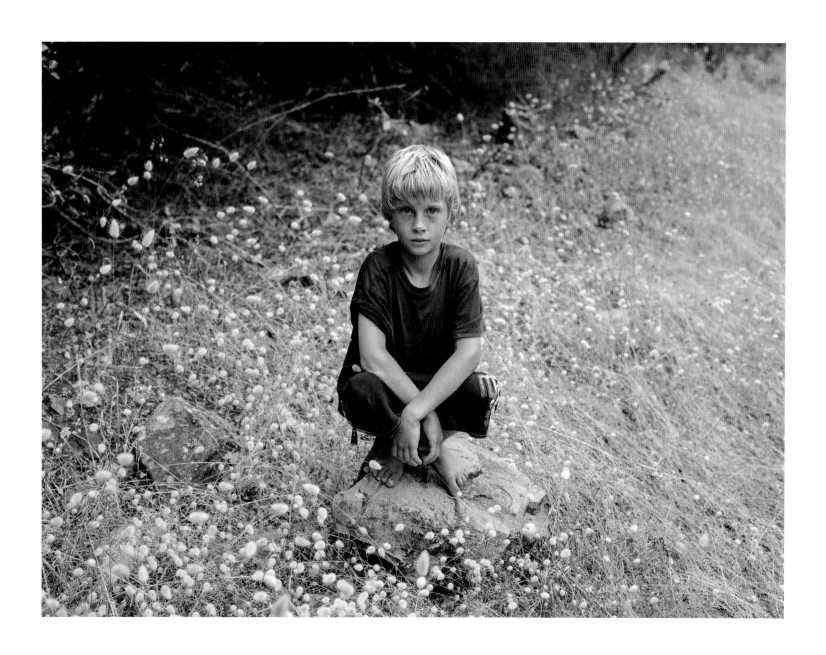

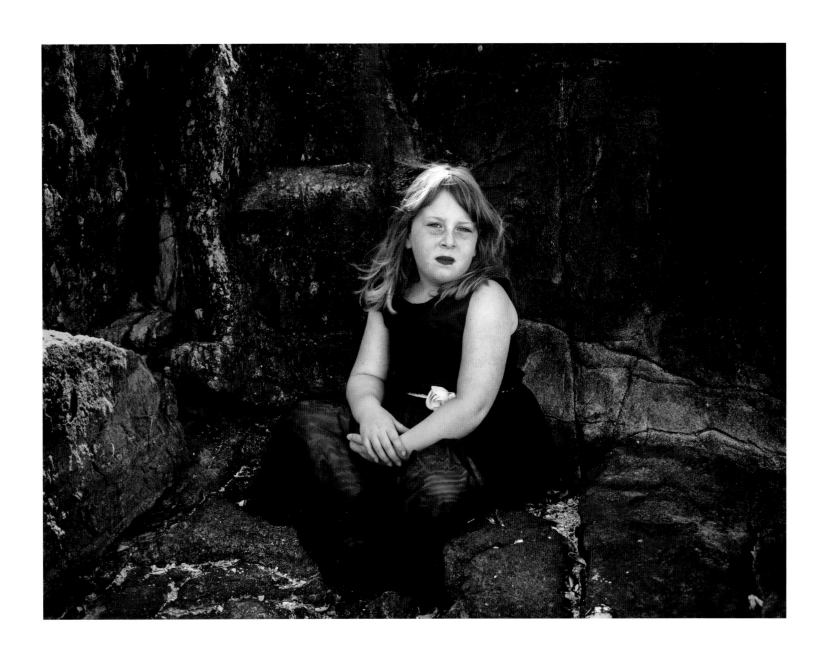

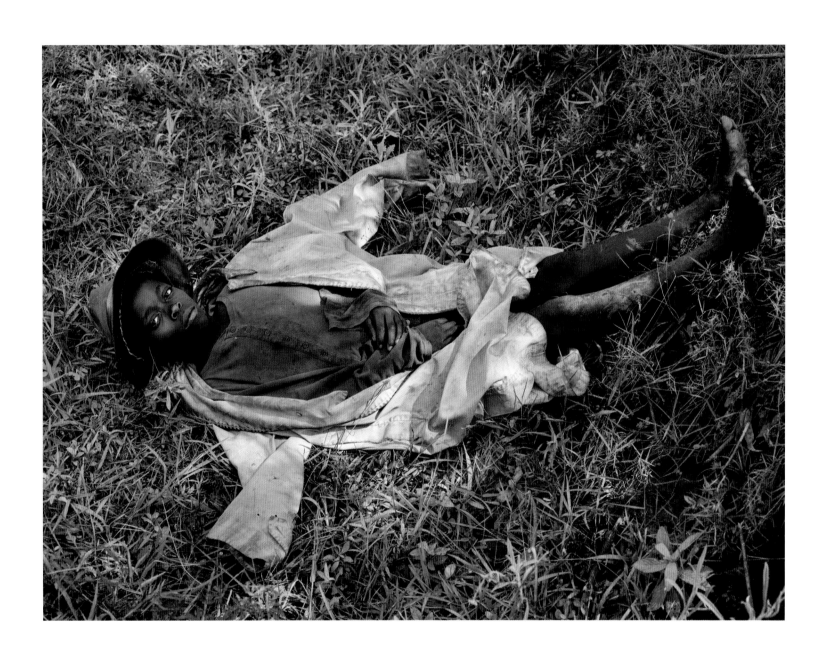

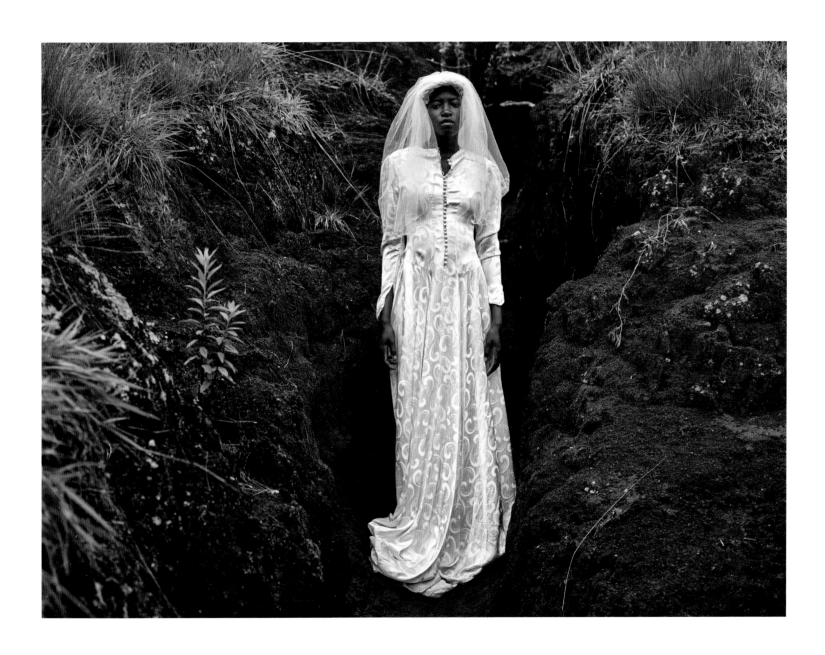

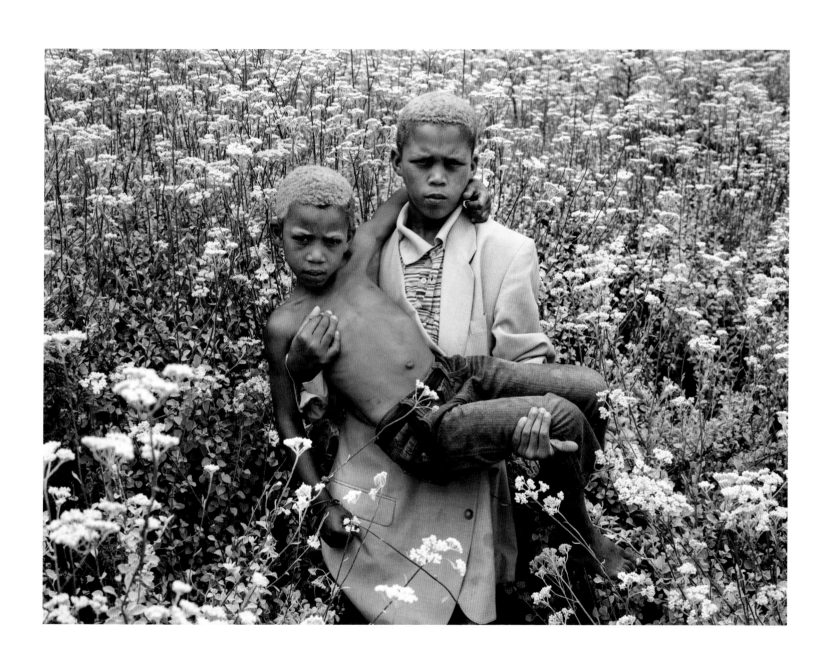

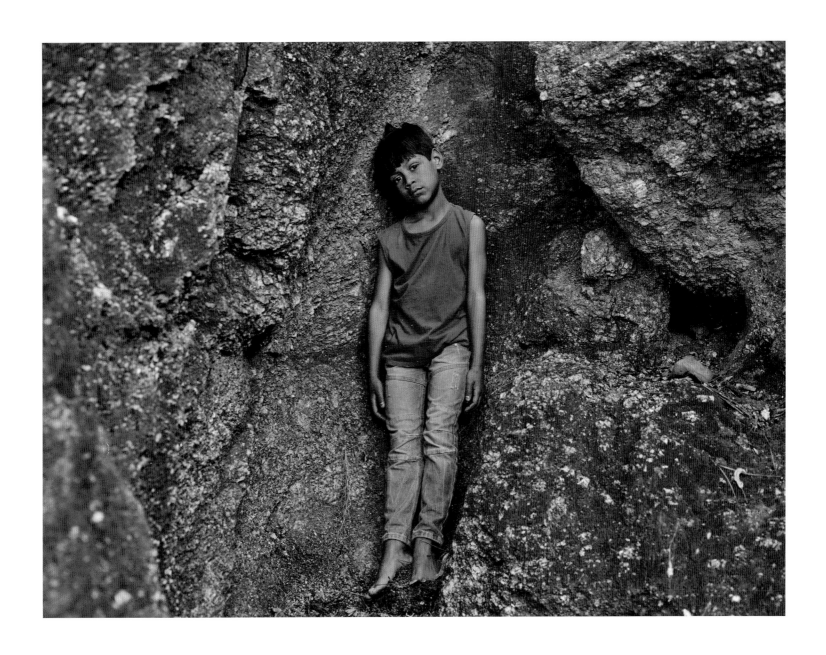

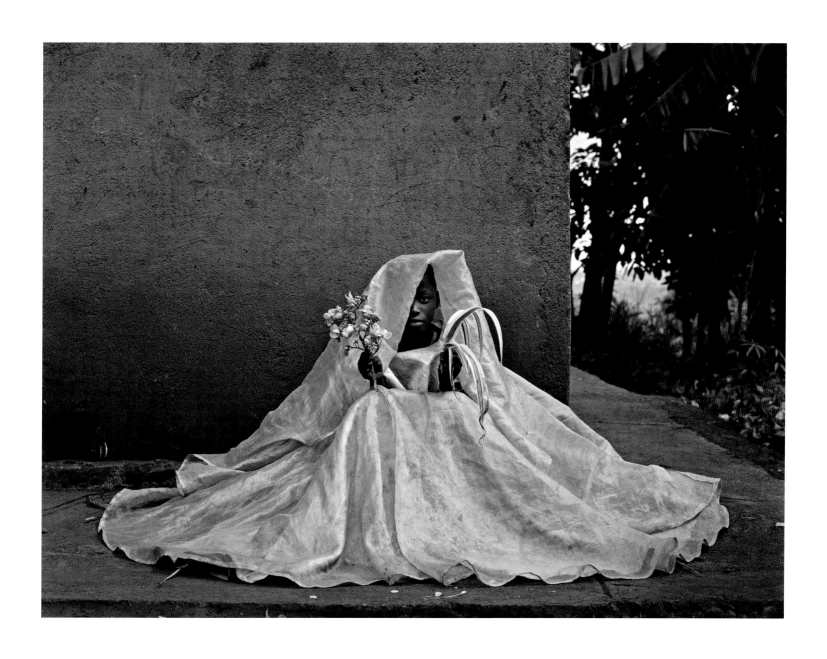

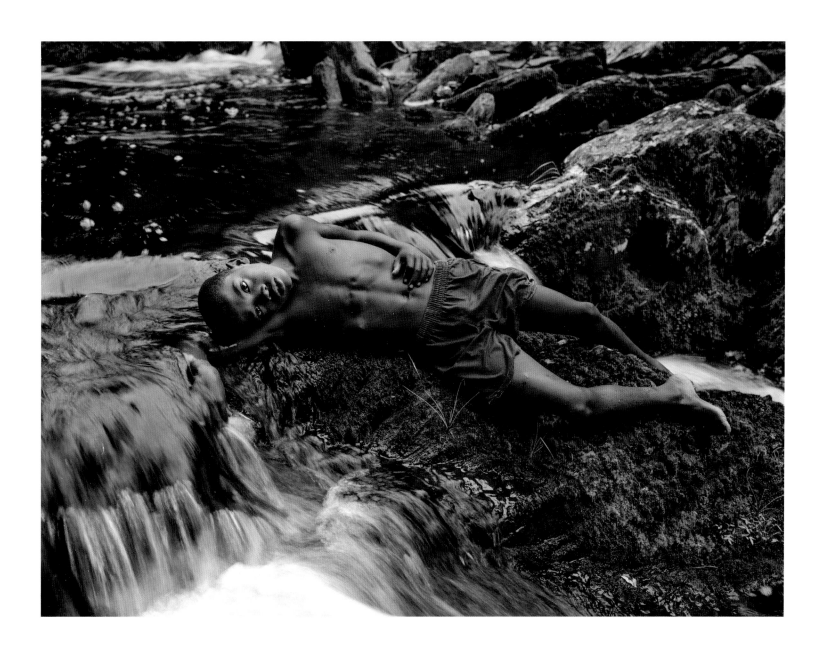

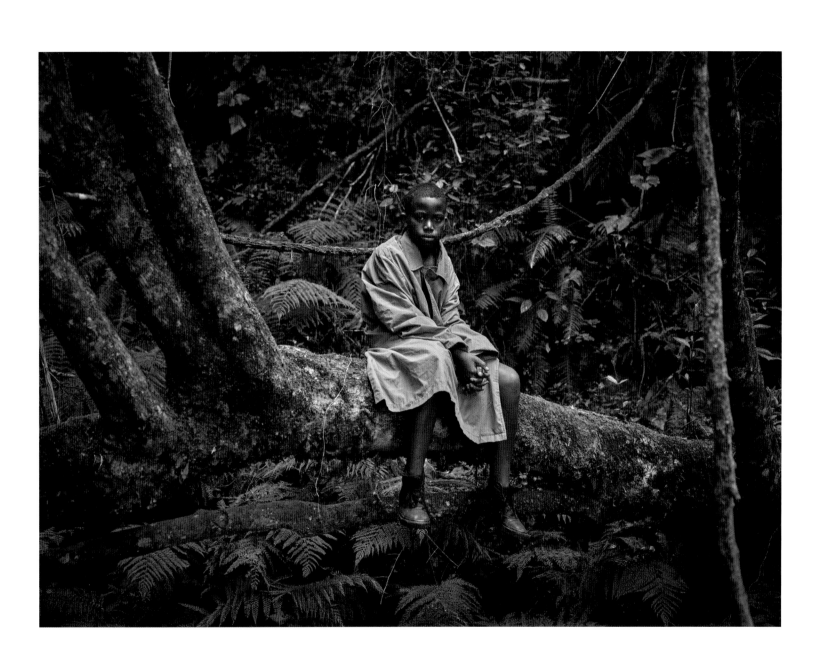

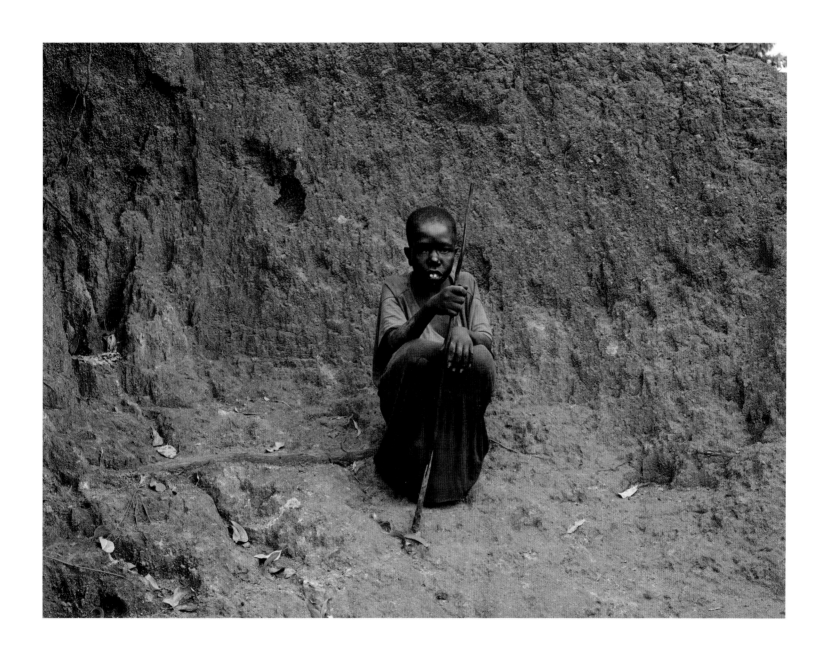

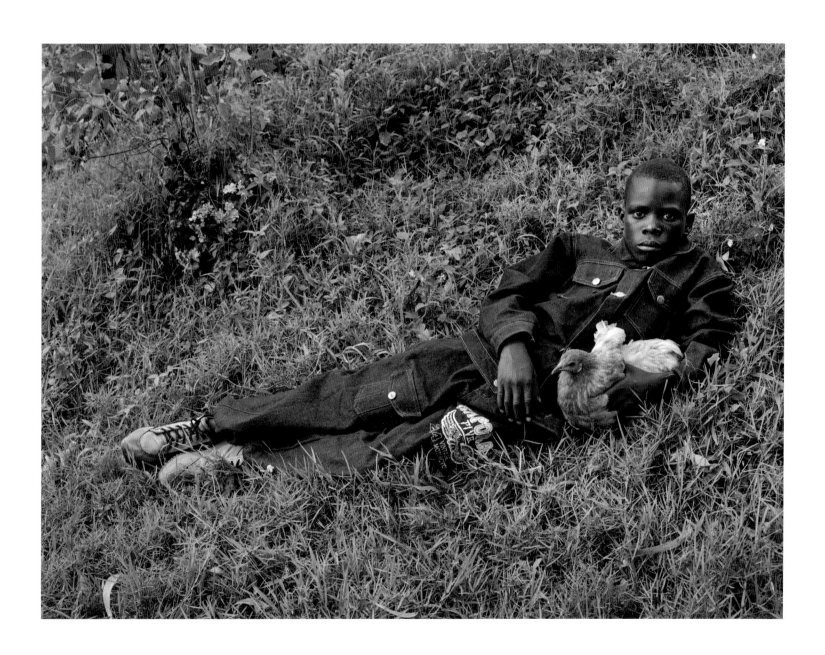

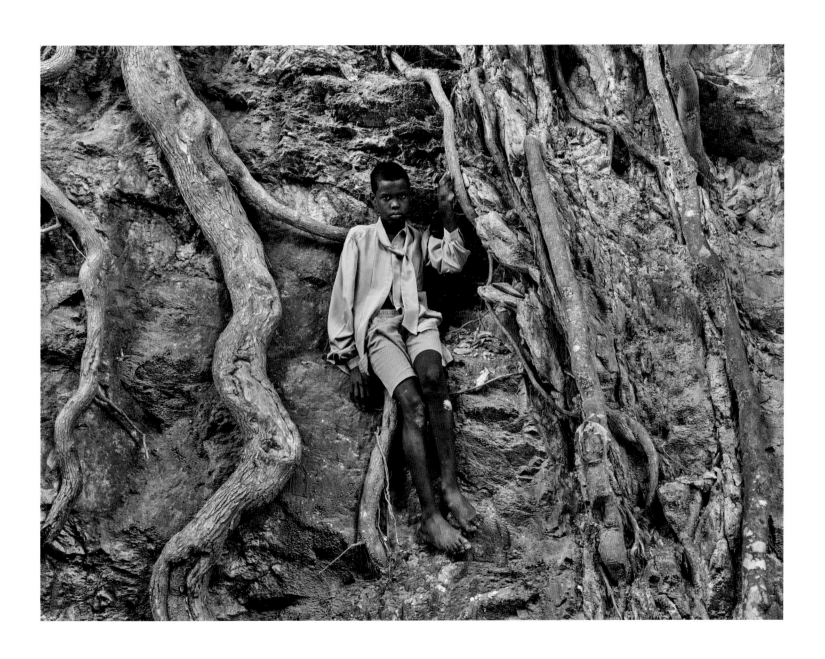

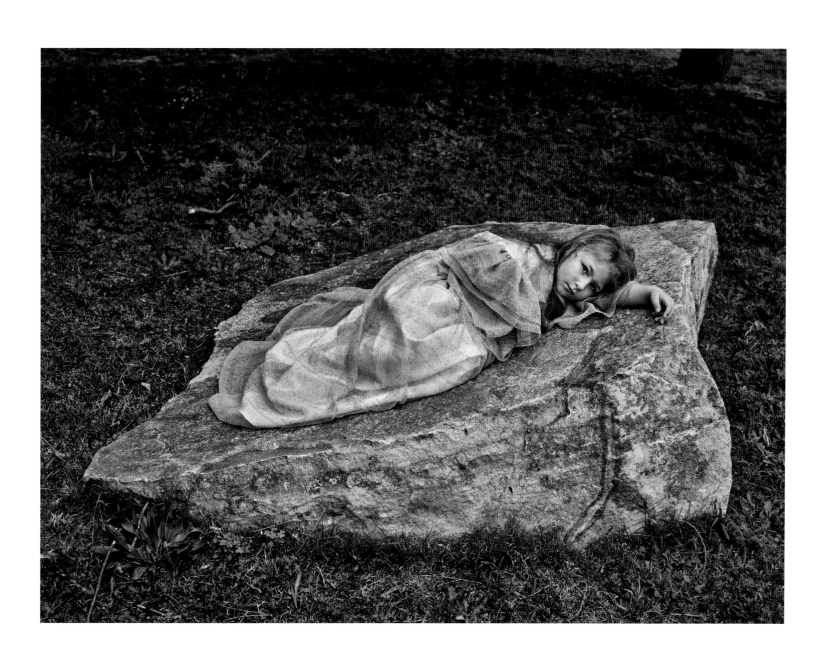

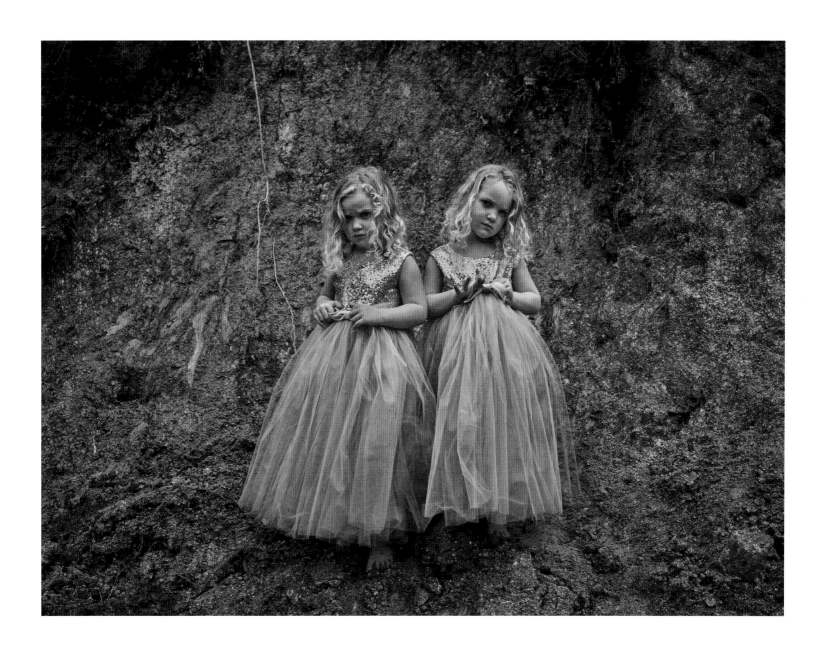

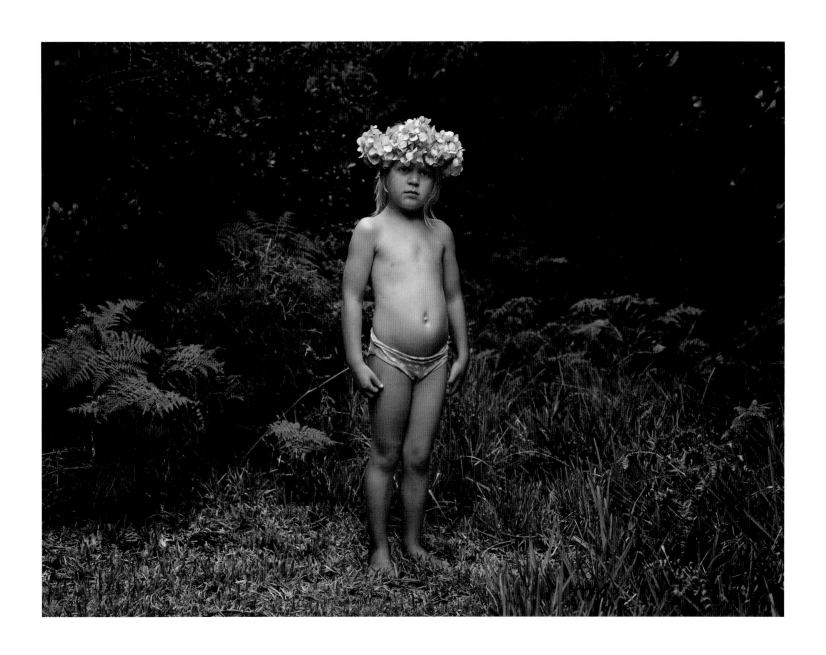

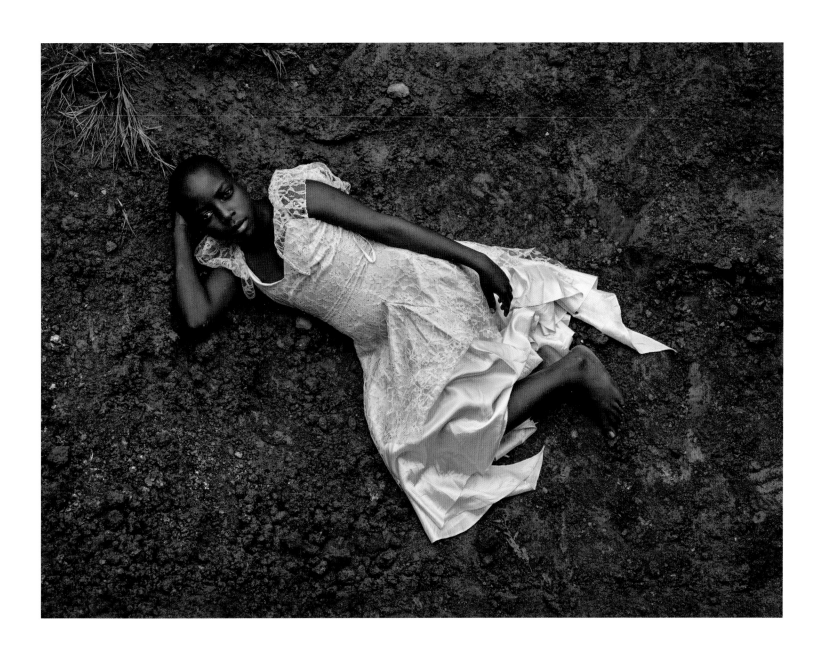

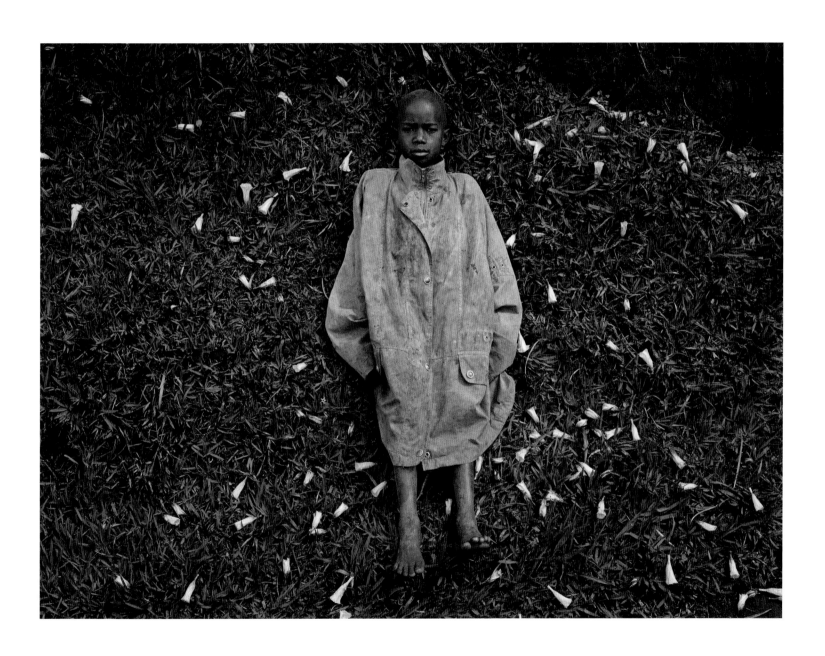

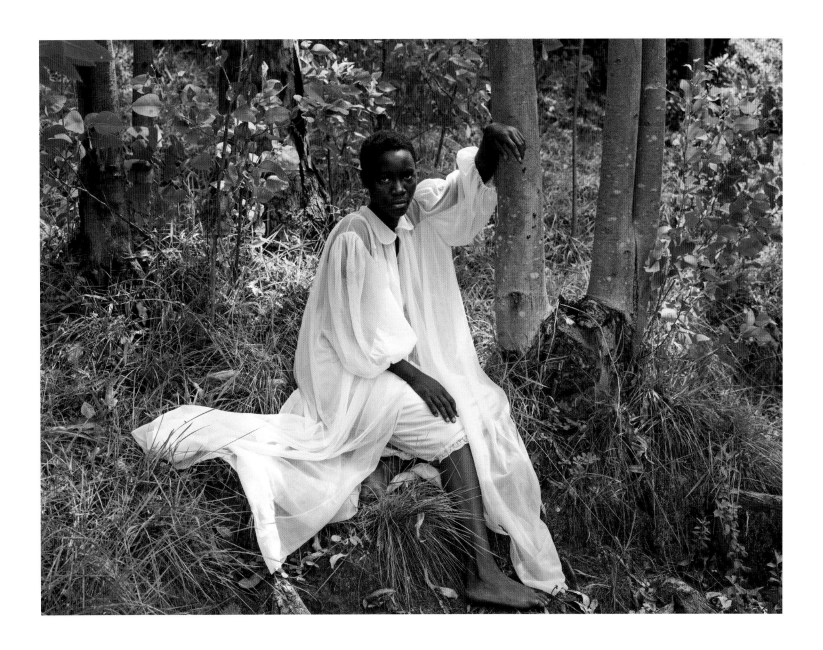

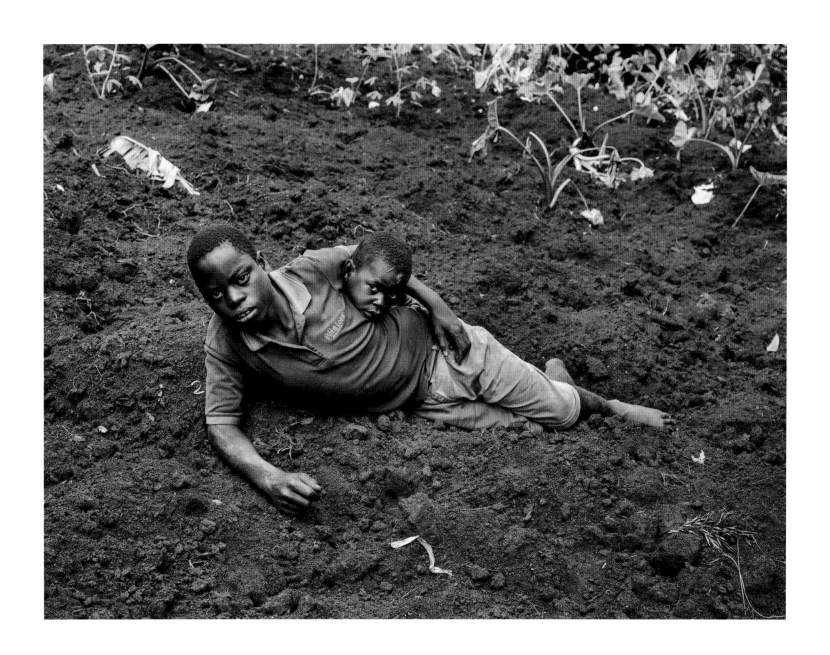

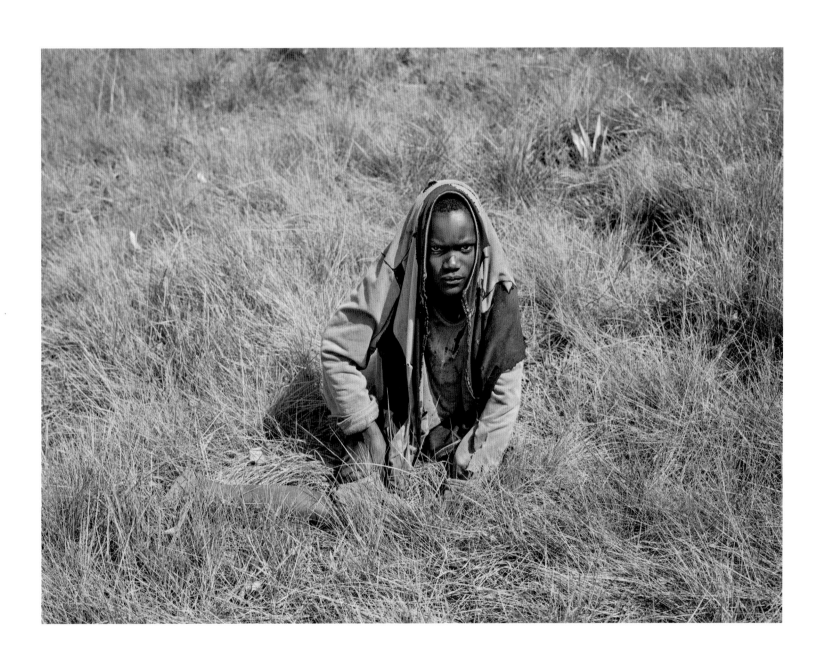

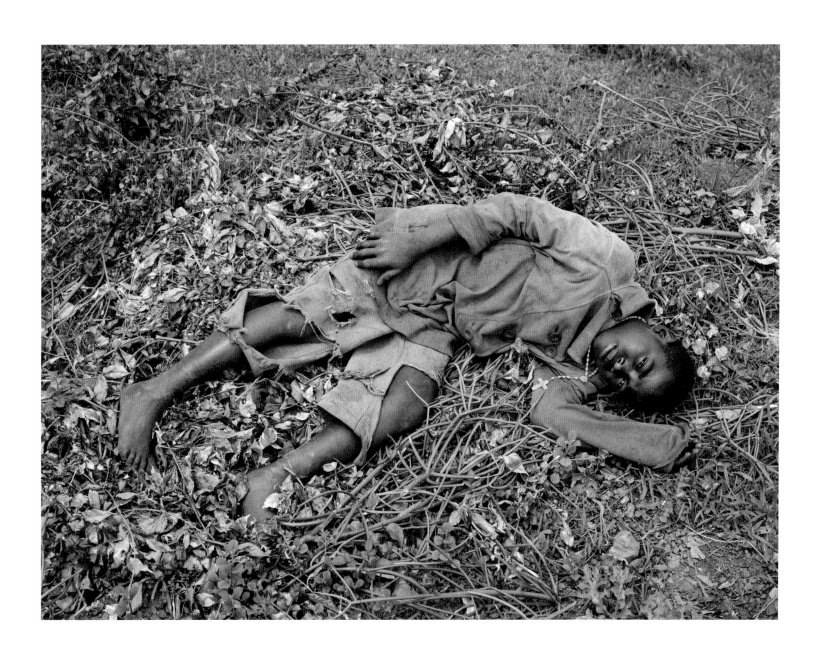

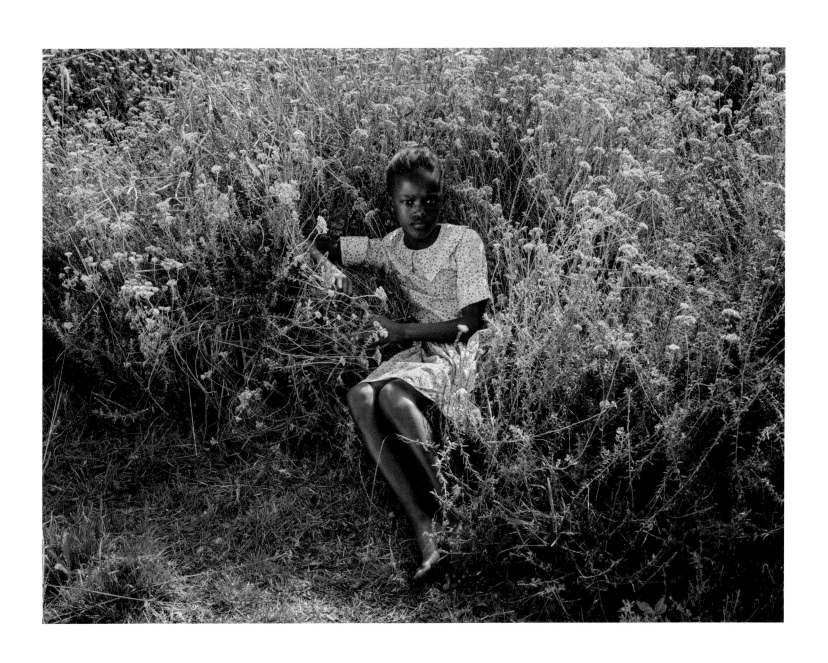

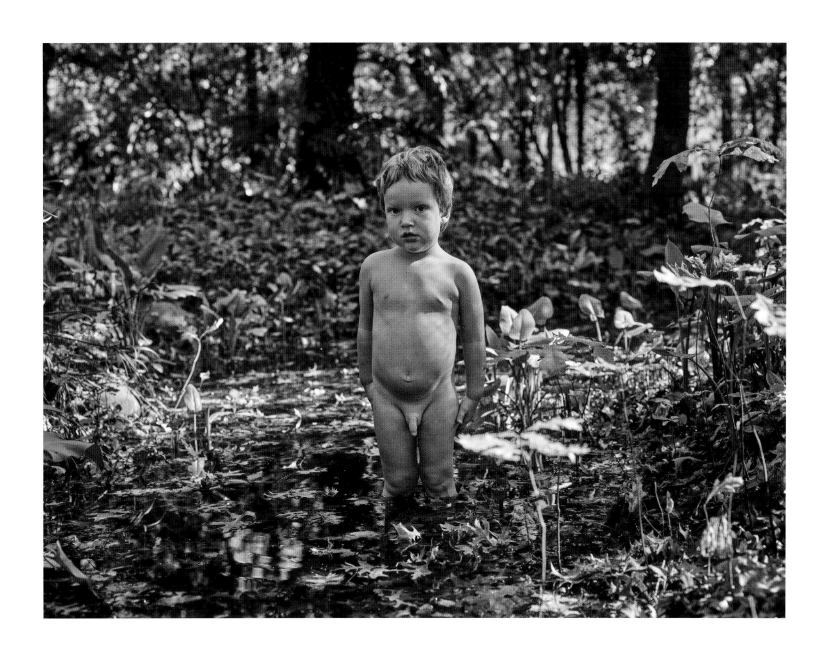

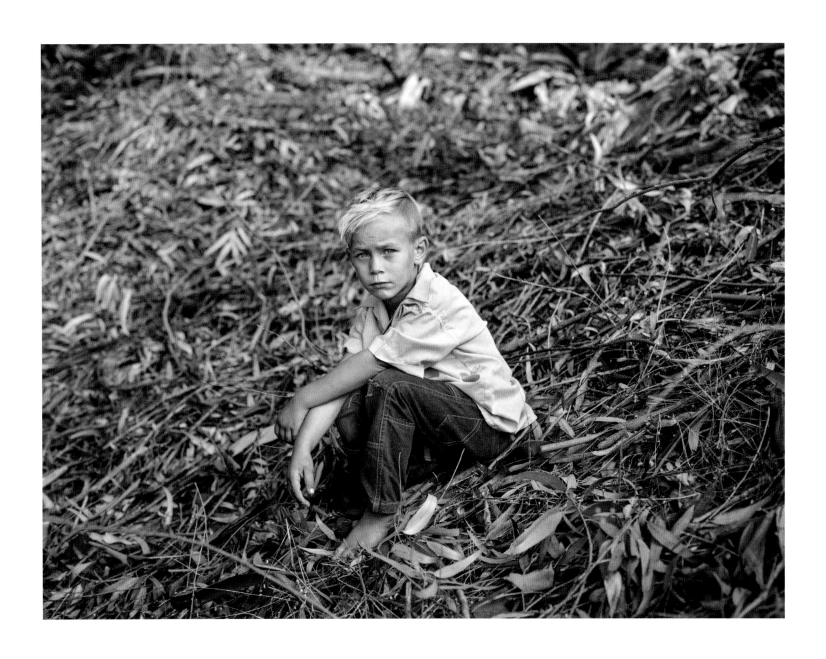

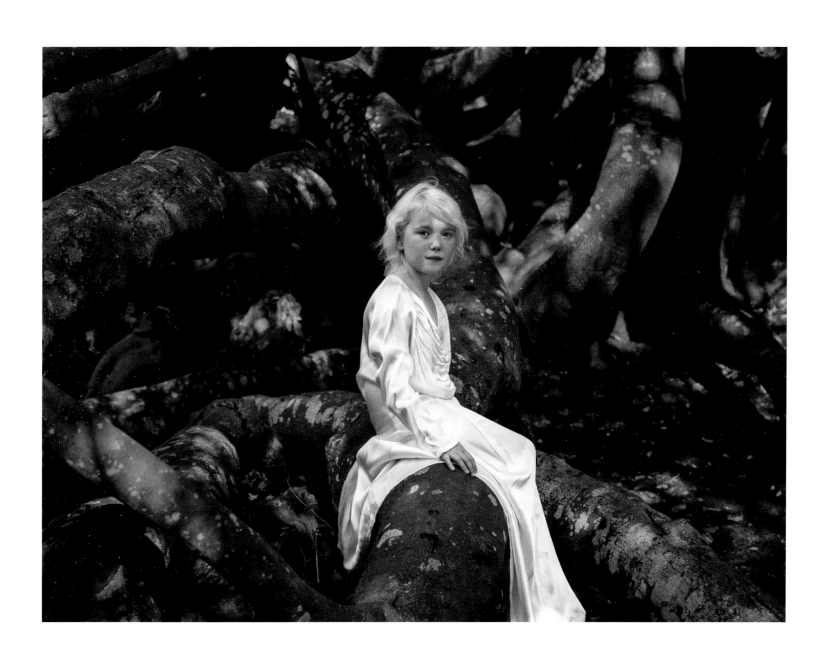

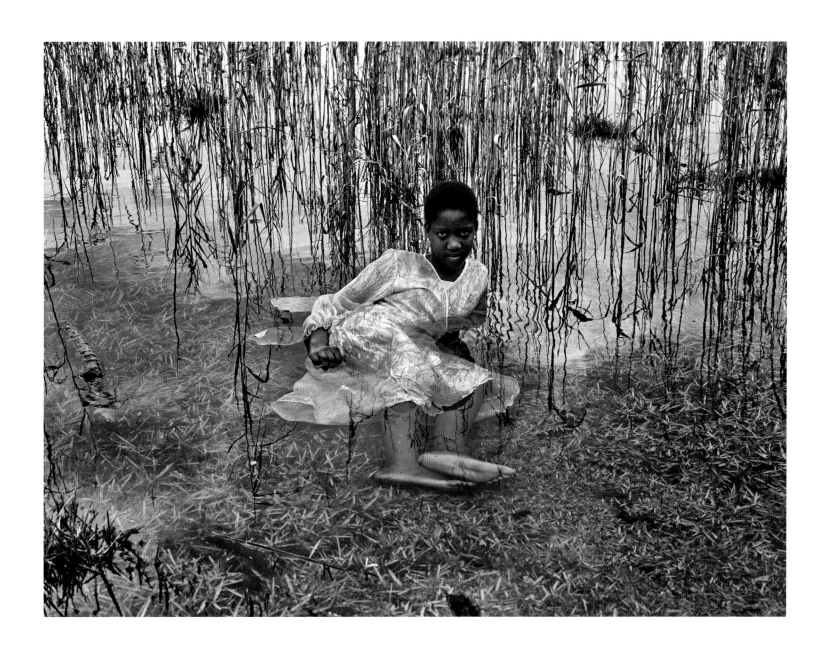

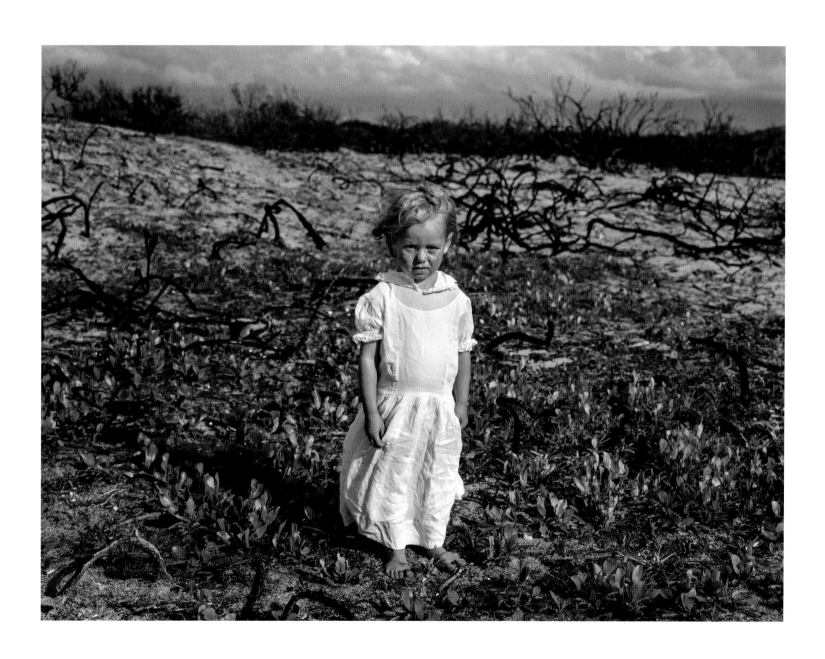

Ashraf Jamal

Giants

In *Boyhood*, JM Coetzee recalls a childhood at odds with the Arcadian fantasy peddled in the *Children's Encyclopaedia*, 'a time of innocent joy, to be spent in the meadows amid buttercups and bunny-rabbits or at the hearthside absorbed in a storybook'. This 'is a vision of childhood utterly alien to him', he bemoans, for 'nothing he experiences … at home or at school, leads him to think that childhood is anything but a time of gritting the teeth and enduring'.

Coetzee has been gritting his teeth ever since, the source of his disaffection *ressentiment*, by its very nature an ungenerous default position that disconnects rather than connects. That Coetzee has persuaded us of the veracity of this perspective – he is widely regarded as 'our best authority on suffering' – has everything to do with the pathological nature of his optic. However, if this extract from *Boyhood* corroborates the prevailing view of the home and the school as sites for the indoctrination, oppression and control of the child, then Pieter Hugo's photographs of children refuse such a dangerously fluent conflation. What follows is an elaboration on this wager.

In his introduction to *White Writing* Coetzee underscored the exilic dread of his 'non-position' by announcing a fraught hiatus in the white colonial imagination: *no longer European, not yet African.* This hiatus, this unsettled non-position, has also profoundly shaped Hugo. My view, however, is that in Hugo's case, unsettlement – belonging yet not belonging – has fostered a very different optic. At no point in his career has the photographer allowed himself the privilege of assuming an authoritative and detached position. Rather, his psychic and exilic unsettlement – his grasp of power and powerlessness – has generated a very different method and means of understanding and seeing the world.

It is of course true that Hugo is in the grip of the panoptic machinery of the camera, what he must, perforce, produce its preternatural vice – reflect the light that bounces off objects, fix his subject in a viewfinder, hold fast the indelible moment. And yet something other also comes into play and that is the very being of the photographer himself.

In our conversation Hugo, who is commonly mistaken as a documentary photographer, is quick to point out the blur 'between documentary and photography-as-art' traditions. This blur, or merger, a constitutive facet of all Hugo's work, is not only a rejoinder against the perception of a photograph-as-a-fact but a desire to affirm a photograph's 'constructed side'. Hugo does not shirk artifice in the making of a photograph. That he chooses, contra David Goldblatt, to omit all captions from his photographs of children, be it their names, age or location, has everything to do with his desire to suspend the fetish of fact.

By eschewing commentary Hugo asserts his inextricability from the moment of taking a photograph. 'One cannot separate who is taking a picture of what,' he says. 'I am who I am in this dynamic.' Here Hugo is telling us that he is someone who has fused with the moment. As a 'White African' – Hugo's self-designation – it is the splice of seemingly in-different worlds – the photographer and the photographed – which gives the photographs their enabling potency. His children are never merely the objects of a vision but creatures re-envisioned in the 'dynamic' of making a moment.

My conversation with Hugo was spurred by the photographer's express need to speak of Rwanda, a country whose genocidal history and fraught democracy he has covered for fifteen years.His Rwandan photographs, which have largely focused on mass grave sites grown 'derelict', 'exhumed', 're-designated', are in many ways a record of the economy of death, an economy

for which the medium of photography has typically operated as a surrogate and handmaiden. However, Hugo's Rwandan 'landscape' cannot or will not be easily packaged or contained. How then is the photographer to see that landscape in which life and death remain snagged, in which one cannot coolly state, after Nietzsche, that the dead far outnumber the living, and thereby allow Thanatos to reign supreme?

Hugo, by way of an answer, chooses to turn his attention to a young girl, dressed for a play-acted 'wedding', and alights upon his first image for his series on Rwandan and South African children. We see the child, veiled, barely visible, yet enveloped in a world as real as it is fantastical. At no point does one sense the intrusiveness of the camera even though it is everywhere in the framing. There is no obvious lesson here and hence no need to provide name, location, age. For what draws the photographer is the very dream world which Coetzee deemed impertinent, a world which Hugo names 'Arcadian'.

It is this twofold vision of Thanatos and Arcadia, death and life, nullity and futurity, which allows Hugo to step away from the numbing, unnumbered, unending wasteland of the dead, the better to exhume or restore life to a nation paranoid, somnambulistic, possessed by its own extinction. For what has compelled Hugo on his last two outings to Rwanda is the photographer's desire in the very grip of death to find the 'unfulfilled promise' of Arcadia.

That Hugo would find the echo of this 'unfulfilled promise' in his homeland would all the more deepen his sense of disconnection and frustration with the world. That said, Hugo is no misanthrope – even though he is commonly perceived as such by those who regard his optic as invasive, exploitative, even pornographic. The root of this common misprision lies in what Coetzee in *Disgrace* describes as 'moral prurience', a censorious moral filter in and through which the world must be ceaselessly moderated. Why, Hugo wonders, must photography be 'humanistic'? 'Since when did art stop being provocative?'

It would be an error, however, to assume that Hugo is solely preoccupied by provocation. Indeed, after Nietzsche, I find his images to be human, all too human. Because his subjects are not framed by a prescriptive or projected value, they are never intended as representational or ideological embodiments. Rather, it is the singularity of the being of the subject, dynamically fused with the photographer's being, which returns image-making to its mortal coil. Hugo's South African children, his own and those of his friends – unjustly countered against his Rwandan image-repertoire as softer in focus, more indulgent, even decadent – reaffirm the unsettlement at the core of his vision.

Knowing Rwanda's genocidal history, and Hugo's desire in the midst of that economy of death to find some release, surely means that his Rwandan image-repertoire must be the more attenuated. To simply ascribe a pathological optic to the artist, to assume that he is merely trafficking in the seduction of Africa's horror story, is to grossly simplify the aggravated crux which generated his vision of Rwandan children. True they are battle-worn, true they seem caught between worlds, one dead and dying, the other powerless to be born, and yet, while caught in this suspended and aggravated moment, Hugo finds a way towards Arcadia.

'Your children are not your children,' Kahlil Gibran declares in *The Prophet*. 'They are the sons and daughters of Life's longing for itself. They come through you but not from you, and though they are with you yet they belong not to you.' And yet, despite this simple and indisputable wisdom, we find children bartered, treated as property in a genealogical fantasy. As the adage goes, 'children are our future'.

This paradoxical damnation of children and their exploitation as a trope for futurity reaffirms the insidious nature of adult authority. Dr Seuss, that great fantasist, is thoroughly justified when he notes that 'Adults are just obsolete children and the hell with them'. But in a world controlled by adults, a world in which, after Coetzee, childhood is 'a time of gritting the teeth and enduring' the better to reproduce the sins of the Father and Mother, such an Arcadian freedom, such revolutionary liberty, is barely countenanced, the child in the circuitry of human exchange rendered forever the surrogate, adjunct, oracle, boon and curse of the adult.

Turning then to that corrosive clich – 'the child should be seen but not heard' – one finds oneself trapped in a seemingly hopeless system in which children remain the victims of power, indentured labour and sexual slavery, among a host of abuses. Like all clichés this one speaks the unspeakable – that children must not and cannot be heard for fear that they will reveal the perversity of our familial, educative, global-corporate core in which children, in one way or another, are systemically wronged. Better, then, that they be seen and not heard.

In the light of this oppressive silence perhaps photography, an optic that can further fix a child, objectify him or her, might be yet another means through which their presence can be controlled. This certainly seems to be the prevailing view. It is as if children cannot or must not be photographed precisely because the medium of photography – appropriative by its very nature – might reveal the dark truth about the powerlessness of children and the root of their abuse.

It is as if the Arcadia which children occupy is one which the adult world must disavow and shatter, be it out of envy, hate or despair, because of its own exile from that world. Tom Stoppard underscores this perversity by noting the erroneous and dangerous assumption that 'Because children grow up, we think a child's purpose is to grow up.' The root of this error in judgment stems from our inability to imagine a childhood freed from the curse of time and history. And yet, as Stoppard adds, 'A child's purpose is to be a child.'

It is the very being of children which we, the aged, have forgotten, or refuse to recall. And yet, despite this perverse resistance, still we must make of children the adjuncts and avatars of a fantasy of some lost world. Which is why we have the 'Lost Boys' and William Golding's *Lord of the Flies* in which every adult self-hatred and violent fantasy must be re-enacted the better to see the boy as the mirror of the man. Today's child soldiers are the monstrous fulfilment of this fatal circuitry of knowledge, belief and experience, in which the child becomes nothing more than a commodity, a vehicle and agent, a creature upon whom a psychic violence must perforce be executed, because within this fatalistic realm there is no childhood immune to the sullied hands of men and women.

It is curious therefore that, while societies worldwide uniformly abuse the rights and freedoms of children, it is children, or rather the *idea* of childhood, that emerges as the ultimate fetish and fantasy of liberation for the aged. If 'youth' is routinely abused, it is as routinely exalted and enshrined. Emblematic of that most avidly sought-after elixir – the 'lost horizon' of eternal

youth – children are reminders of our lost past, our supposed innocence, which is why they are despised all the more, and why we, the aged despisers of the free will of children, inaccurately declare that 'youth is wasted on the young'.

Given this soulless celebration and oppression of children in societies worldwide, what are we to make of Hugo's photographic reading of a grouping of children from South Africa and Rwanda, because, of course, no photograph is innocent, and neither is its subject.

Hugo's strength lies in his weakness – he refuses to wholly control the subject seen, choosing an intercommunicative 'dynamic'. It is important to note that this process is not simply an exercise in compassion. Hugo is not reinstating the core principle of Martin Buber – a survivor of Europe's 'murder factories' – who in *I and Thou* notes: 'I imagine to myself what another man is at this very moment wishing, feeling, perceiving, thinking, and not as a detached content but in his very reality, that is, as a living process in this man.' Rather, to account for how the exchange occurs, just what it is that Hugo seeks to bring into effect, let me return to my first encounter with his photographs of children.

In the gallery context the children appear on a human scale, they accompany us and watch us as we silently absorb their presence. For of course galleries are sanctums, zones of silence where the sacred and the profane commingle. Indeed, the gallery experience with its conventional emphasis on silence and visibility reproduces the toxic equation typically affixed to children. However, such a punitive view was not vouchsafed by the experience itself, for it was never Hugo's intention merely to sanctify the fetish of looking or to consecrate the image as a silent object of exchange. Rather, as if willing the very inverse of a culture that seeks to abbreviate, foreshorten, and empty the moment of exchange between the viewer and the viewed, Hugo sought to open up and aerate the moment of insight.

Once again I was reassuringly struck by the fact that the photographs are staged, set up, because for me this has always been the defining moment in experiencing a Hugo photograph. And if this reflexive staging has proved a fulcrum for the photographer's entire oeuvre, this is because Hugo has always perceived his own life as staged – a position between positions, authentic yet not, European yet African, documented yet artful, in and out of place.

It is this dissonance, this glitch, which also inhabits the moments he captures, for one notices in Hugo's children not only the postures, or poses, some awkward, as though the child were rearranged like any other prosthetic, but also the clothing that shrouds them which, glaringly, suggests the dress-up. A Rwandan girl reclines upon an escarpment of rich red-brown soil in a gold-sequined mini-dress; a pale blonde South African girl is seated in a forest attired in a period slip from the 1920s. When I ask Hugo about this choreography he returns me to his abiding taste for an image showing some awareness of its constructed nature.

There is a further surprise, for the clothing with which he bedecks his Rwandan children – 'garments oversized, donated by Scandinavia' – ramifies the fold of centre and periphery, North and South. These are not blatantly politicised projections of a hemispheric conflict. The children are not ciphers nor are they empathic figures for some global parity. Rather, the fact that we are engaging with children – albeit silenced and imaged – stays uppermost in the viewing process.

Precocity pervades every one of Hugo's photographs. This precocity or self-knowing is not the upshot of the adage that 'one is wiser than one's years'. Indeed, the last thing that Hugo is interested in entertaining is our perverse relationship with youth, our desire to either destroy or idealise it. Despite the fact that he has composed, designed, lit his subjects, they are not fetish objects or glibanthems to beauty. Rather each subject pulses, fixes our eye, disturbs our composure. That they do so *without* aggression, *without* placing some moral demand upon us, *without* triggering our guilt, reveals the power of Hugo's images – they are all-importantly extra-moral, occupying a space outside of the grim circuitry of the exploitative economy of youth.

A brown bare-chested boy in shorts lounges at the lip of a forest stream, his one hand propped at the waist, the other immersed in the glittering rush of water. The gaze is direct, the full lips glitter in the dappled light. I am reminded of the classic odalisque, the reclining nude, of centuries of posturing, of seduction. Another boy, blond, crouches, his bare feet clamped to a boulder; his eyes, red, glare unflinchingly, a crude scribble of a smile crosses his lips. It is the self-presence of this boy that binds one, the great reach of his selfhood, his boyhood, and the African ground that has birthed it. For these are images of African children. These are the giants which Ingrid Jonker dreamt of in her poem 'The child who was shot dead by the soldiers in Nyanga', which Nelson Mandela eulogised in his inaugural speech in 1994.

Giants by Ashraf Jamal

The child is not dead
The child raises his fists against his mother
Who screams Africa screams the smell
Of freedom and heather
In the locations of the heart under siege

The child raises his fists against his father
In the march of the generations
Who scream Africa scream the smell
Of justice and blood
In the streets of his armed pride

The child is not dead
Neither at Langa nor at Nyanga
Nor at Orlando not at Sharpeville
Nor at the police station in Philippi
Where he lies with a bullet in his head

The child is the shadow of the soldiers
On guard with guns saracens and batons
The child is present at all meetings and legislations
The child peeps through the windows of houses and into the hearts of mothers
The child who just wanted to play in the sun at Nyanga is everywhere
The child who became a man treks through all of Africa
The child who became a giant travels through the whole world

Without a pass

Much gratitude to:
Joel Karakezi, Rabia Benlahbib at the Creative Court,
Anke Loots, Johmar Pretorius, Andrew McIlleron,
Ashraf Jamal, Shamus Clisset, Michael Stevenson,
Federica Angelucci, Priska Pasquer, Sophie Perryer,
Raphaelle Jehan, Deslynne Hill, Yossi Milo, Alissa
Schoenfeld, Phillip Prodger and Clementine Williamson
from The National Portrait Gallery, Martine Gosselink
from the Rijksmuseum, and a special thank you to
Sophia, Jakob and as always to The Peanut.

Prestel Verlag,
A member of Verlagsgruppe Random House GmbH,
Munich / London / New York 2016
© for photographs Pieter Hugo 2016
© for text Ashraf Jamal 2016

Prestel Publishing Ltd.
14 — 17 Wells Street, London W1T 3PD

Prestel Publishing
900 Broadway, Suite 603, New York, NY 10003

Library of Congress Control Number is available;
British Library Cataloguing-in-Publication Data: a catalogue
record for this book is available from the British Library;
Deutsche Nationalbibliothek holds a record of this
publication in the Deutsche Nationalbibliografie; detailed
bibliographical data can be found under: http://www.dnb.de

Design and layout: Joseph Burrin
Copy-editing: Sophie Perryer
Print management: Wonderful Books
Printing and binding: Wilco Art Books
Paper: Magno Satin, IBO One, Colorplan Mist,
Wibalin Natural Fawn, Classical Pearl Pink

Verlagsgruppe Random House
FSC ®NOO1967
ISBN 978-3-7913-8273-9
www.prestel.com